*celebrating
modern
art* | HIGHLIGHTS *of the* **ANDERSON COLLECTION**

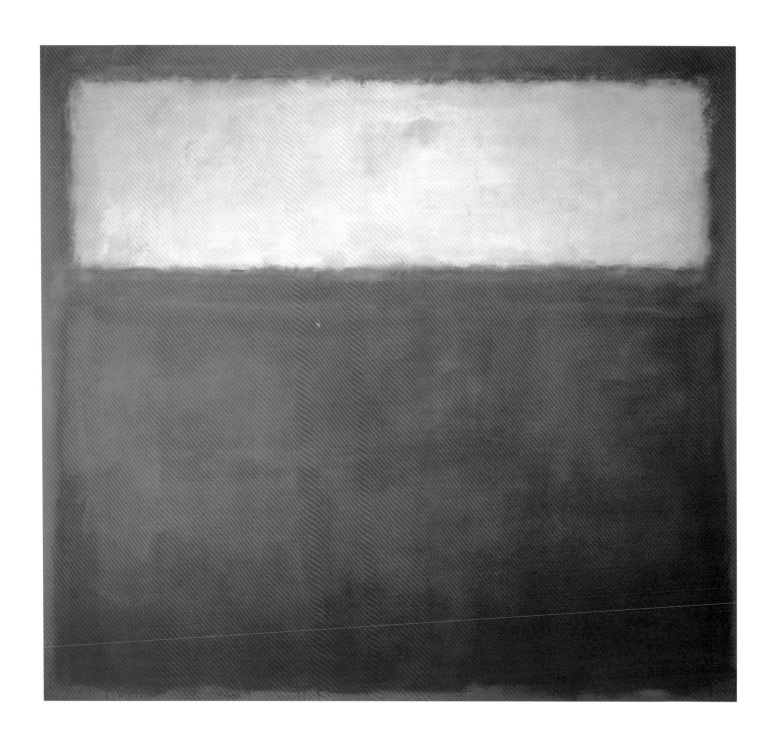

San Francisco
Museum of
Modern Art

celebrating
modern
art

HIGHLIGHTS *of the* **ANDERSON COLLECTION**

This catalogue is published on the occasion of the exhibition *Celebrating Modern Art: The Anderson Collection*, organized by Gary Garrels at the San Francisco Museum of Modern Art and on view from October 7, 2000, to January 15, 2001.

This exhibition is supported by the Board of Trustees of the San Francisco Museum of Modern Art and the Modern Art Council, a Museum auxiliary. Additional generous support is provided by Doris and Donald Fisher, Helen and Charles Schwab, Evelyn D. Haas, Phyllis Wattis, Mimi and Peter Haas, Patricia and William Wilson III, and Elaine McKeon.

Library of Congress Cataloging-in-Publication Data:

Celebrating modern art : highlights of the Anderson Collection

 p. cm.

 Published on the occasion of an exhibition held at the San Francisco Museum of Modern Art, Oct. 7, 2000 – Jan. 15, 2001.

 ISBN 0-918471-61-3 (pbk.)

 1. Art, Modern—20th century—Exhibitions. 2. Anderson, Harry W.—Art collections—Exhibitions. 3. Anderson, Mary Margaret—Art collections—Exhibitions. 4. Art—Private collections—California—Exhibitions. I. San Francisco Museum of Modern Art.

 N6488.5.A53 C449 2000
 709'.04'007479461—dc21

 00-058769

Publications Director: Kara Kirk
Publications Manager: Chad Coerver
Publications Coordinator: Alexandra Chappell
Editor: Fronia Simpson
Designer: Jody Hanson

Printed and bound in Italy by Mondadori Printing

PHOTOGRAPHY CREDITS

Unless otherwise noted below, all copy photography is by Lee Fatheree, courtesy of the Anderson Collection. All works are reproduced with the permission of the Anderson Collection and the artists, their estates, or the representatives listed below:

Robert Arneson: ©Estate of Robert Arneson/ Licensed by VAGA, New York, NY; Jean (Hans) Arp: ©2000 Artists Rights Society (ARS), New York/VG Bild-Kunst, Bonn; Willem de Kooning: ©2000 Willem de Kooning Revocable Trust/Artists Rights Society (ARS), New York; Jim Dine: ©1981 Jim Dine (courtesy of PaceWildenstein; photo by Ben Blackwell); Sam Francis: ©2000 The Estate of Sam Francis/Artists Rights Society (ARS), New York; Alberto Giacometti: ©2000 Artists Rights Society (ARS), New York/ADAGP, Paris; Arshile Gorky: ©2000 Estate of Arshile Gorky/Artists Rights Society (ARS), New York; Jasper Johns: ©Jasper Johns/Licensed by VAGA, New York, NY (photo by Ben Blackwell); Franz Kline: ©2000 The Franz Kline Estate/Artists Rights Society (ARS), New York; Roy Lichtenstein: ©Estate of Roy Lichtenstein; Jacques Lipchitz: ©Estate of Jacques Lipchitz/Licensed by VAGA, New York, NY/ Marlborough Gallery, NY; Henri Matisse: ©2000 Succession H. Matisse, Paris/Artists Rights Society (ARS), New York; Robert Motherwell: ©Dedalus Foundation, Inc./Licensed by VAGA, New York, NY (photo by Camerarts); Emile Nolde: ©Nolde-Stiftung Seeb.ll; Jackson Pollock: ©2000 Pollock-Krasner Foundation/Artists Rights Society (ARS), New York; Robert Rauschenberg: ©Untitled Press, Inc./ Licensed by VAGA, New York, NY (photo by Ben Blackwell); Mark Rothko: ©1998 Kate Rothko Prizel & Christopher Rothko/Artists Rights Society (ARS), New York (photo by Ian Reeves); David Smith: ©Estate of David Smith/Licensed by VAGA, New York, NY; Frank Stella: ©2000 Frank Stella/Artists Rights Society (ARS), New York; Robert Therrien: ©2000 Robert Therrien/Artists Rights Society (ARS), New York; Wyne Thiebaud: ©Wayne Thiebaud/ Licensed by VAGA, New york, NY; Andy Warhol: ©2000 Andy Warhol Foundation for the Visual Arts/ARS, New York (photo by Ben Blackwell)

COVER:
Wayne Thiebaud
Candy Counter, 1962 (detail)
oil on canvas
55¼ x 72 in.

FRONTISPIECE:
Mark Rothko
Pink and White over Red, 1957
oil on canvas
105 x 116 in.

ONE OF THE MARKS of a great art collection is that it does not easily adhere to the categories that we often assign to individual artists or movements. Rather, the unexpected juxtaposition of artworks brought together under the collector's eye forces us to see the relationship between artists and their creations in a new light. The exhibition *Celebrating Modern Art: The Anderson Collection* is intended to document one such collection. Harry W. and Mary Margaret Anderson have assembled a breathtaking array of artworks by many of the most important artists of this century. The San Francisco Museum of Modern Art is honored to bring a great number of these works into the public eye for the first time.

Like all SFMOMA projects, *Celebrating Modern Art* is the result of a team effort. In particular, I would like to thank Gary Garrels, former Elise S. Haas chief curator and curator of painting and sculpture, for bringing his insight and enthusiasm to the largest exhibition ever mounted by the Museum. Gary shared organizational oversight of this project with Lori Fogarty, senior deputy director, who brought leadership and good humor to the coordination of myriad tasks and personnel. Heartfelt thanks are also due to the entire Anderson staff—and especially Molly Hutton and Rachel Teagle—for their contributions to this enterprise.

Given the extraordinary breadth and complexity of the Anderson Collection, selecting a representative group of some fifty highlights for this volume would seem to be impossible. But we have made the attempt in the hope that the publication will serve as a point of departure for exploring the collection further while it is on view at SFMOMA. Janet Bishop, Julia Bryan-Wilson, Martin Fox, Molly Hutton, and Rachel Teagle have provided an excellent set of writings that illuminate the unique set of circumstances that go into the creation of any artwork. Amy Pitsker

DIRECTOR'S FOREWORD DAVID A. ROSS

has seamlessly interwoven the writings of others to produce an interesting and informative overview of the collection. All of these texts were edited with great care and expertise by Fronia Simpson. The elegant design is the work of Jody Hanson, whose sensitivity to a wide variety of artistic styles is evident throughout. Finally, the entire project was expertly managed by the publications team at SFMOMA, in particular Alexandra Chappell, publications coordinator.

It is our sincere hope that in leafing through these pages others will experience some of the same joy and enthusiasm for modern art that Harry W. and Mary Margaret Anderson have shared with us throughout this process. It is to them that we owe the greatest debt for making this exceptional undertaking a reality.

OVER THE PAST THIRTY-FIVE YEARS Harry W. and Mary Margaret Anderson have assembled one of the most extraordinary private collections of twentieth-century art in the world. Throughout the century, private collections of similar quality have greatly influenced our understanding of modern art. The passions and generosity of individuals have helped shape museum collections, and in turn, exhibitions of private collections provide public access to artworks and reveal how individual connoisseurship shapes the development of art history. *Celebrating Modern Art: The Anderson Collection* is the first exhibition to bring to public attention the remarkable breadth and caliber of the works the Andersons have acquired. Included are some of the most important works by many of the most pivotal artists of the twentieth century. More than a treasury of masterworks, the collection proves valuable for the richness and texture of works brought together, the dialogue of ideas that unfolds, and the fresh insight it provides into familiar categories of modern and contemporary art.

The scale of this project—more than 330 works from a total of more than 800—makes it one of the largest showings of a private collection ever mounted and the largest exhibition ever presented by SFMOMA. It has been organized in five sections—the New York School, California Art, Contemporary Art, Modern Sculpture, and Works on Paper—any one of which could be an exhibition in itself. The scope and organization of the project mirror the history of the development of the Andersons' interest in art and their evolving sense that they were assembling what they like to call a "collection of collections." While transcending the notion that art gathered by individuals simply reflects personal taste, the Anderson Collection, seen in its full range, reveals a distinct approach to the art of the past one hundred years.

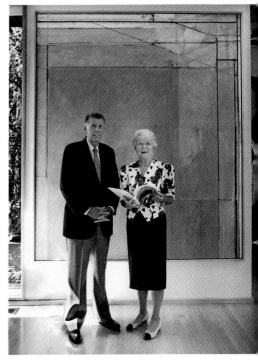

Harry W. and Mary Margaret Anderson
in front of Richard Diebenkorn's
Ocean Park #60, 1993
Photograph by Leo Holub

An INTRODUCTION *to the* ANDERSON COLLECTION

The New York School encompasses work by artists living in New York from 1945 through the 1960s, including those associated with such movements as Abstract Expressionism, Color Field, Pop art, and Geometric Abstraction. Displayed in the California Art section are works created from the 1940s to the present day, from early abstract paintings through California Funk and assemblage works to contemporary experiments in new materials by artists from both Southern and Northern California. Contemporary Art gathers work by artists who broke from the rigorous formal and intellectual concerns of the generation that followed Abstract Expressionism and Pop art to pursue more personal approaches. The Works on Paper section of the exhibition traces this kind of formal experimentation

in drawings, watercolors, gouaches—many of which are by artists featured in other areas of the exhibition. The Andersons' collection of Modern Sculpture traces the trajectory of sculpture from Europe in the late nineteenth century to the United States in the mid-twentieth century.

The core values at the heart of the collection can be described as the tension between abstraction and figuration and an interest in the artist's hand. These focal points counter a popular critical position of the past forty years that has favored both abstraction and an intellectual approach that emphasized the idea or concept behind an artwork. The Anderson Collection embraces an alternative stance, one whose importance becomes more evident as the work of many represented artists continues to evolve, mature, and garner critical accolades.

The Andersons—known as "Hunk" and "Moo"—quickly fell in love with modern art on a trip to Paris in 1964. Hunk recalls the trip as a turning point: "Something came over us in the Louvre, we felt for the first time the beauty and excitement of the world of art and had to be a part of it."[1] After seeing modern masterworks by Claude Monet, Paul Cézanne, and Henri Matisse in the Parisian museums, the Andersons came home with the desire to collect the Impressionist works they loved. Toward that end, they acquired paintings by Claude Monet, Camille Pissarro, and Pierre-Auguste Renoir. They also purchased a number of contemporary works that revealed ties to the Impressionist aesthetic.

Despite the beauty of the Impressionist works the Andersons acquired, they quickly became frustrated with the quality and quantity available to them. They wanted not simply an artist's representative works, they wanted an artist's best works, and most of all they wanted a great collection of art. At this point, assembling Impressionist paintings of high quality seemed an impossible goal. So the Andersons shifted their attention to more contemporary art and began exploring "American modern" as their collecting objective.

Yet the Andersons continued to use Impressionist ideals as organizing principles for their contemporary collection. The Impressionists' radical embrace of the new, the challenge inherent in their art, and the virtuosity of the artist's touch were qualities that spoke directly to the Andersons' sensibility. In addition, the Andersons' early acquisitions were inevitably affected by the time in which they began to collect: the couple shared the era's focus on paint application as more than merely a means to an end. The Abstract Expressionists' famous, if not infamous, paint handling caught the Andersons' attention. Beginning with the acquisition of Abstract Expressionist paintings, the Andersons used their interest in the artist's

touch as an elegant and conceptually flexible framework on which to build their collection. As Hunk explains: "In all our work the head and the hand must be present."

In 1969, a pivotal year for the Andersons, the couple purchased a remarkable painting that points to themes that would come to define the collection. Richard Diebenkorn's *Girl on the Beach* (1957) reflects major tensions in an American art world struggling to redefine itself in the wake of Abstract Expressionism.

Like so many paintings from the period, and many of the other paintings in the Anderson Collection, Diebenkorn's *Girl* embodies a struggle between the poles of abstraction and figuration. While the model is clearly the emphasis of the painting, her figure is ever ready to recede into flat abstraction. In particular, the girl's striped skirt, strategically placed at the center of the image, highlights a potentially double function of line: both as a boundary of form and simply as a painterly motif. Through this ambiguity, Diebenkorn explored what direction art following Abstract Expressionism might take in a careful balance between abstraction and figuration.

In the late 1960s the Andersons may have been attracted to works that embraced such ambiguity because at that point the direction of their collecting was not yet resolved. By 1969, the Andersons were focused on the goal of building a "modern" collection, and they defined "modern" in the broadest of terms. A search for the new, or, as Hunk likes to call it, a "journey to the new," became a significant feature of their "modern art." Before considering a new addition, Hunk and Moo always ask, "Have I seen it before?" The quest for unique approaches was difficult for two people with no formal training in the arts and for whom every discovery was exciting. The couple met while attending college in upstate New York in the 1940s, he at Hobart College in Geneva and she at D'Youville College in Buffalo. In his senior year at Hobart, Hunk focused his entrepreneurial skills and founded the Saga Corporation, a food service provider, with two classmates.

When a joint headquarters operation for Saga was established in Menlo Park, California, the Andersons' collecting and art education shifted into high gear. Friends from Stanford University, Moo's interest in books, a print subscription with Gemini G.E.L., and a healthy respect for the contingencies of the art market all contributed to their art education and to the shaping of their collection.

As the Andersons continued their education and their acquisition of paintings, sculptures, works on paper, and prints, they refined their artistic interests to give the collection its character and individual spirit. In the early 1970s, artist and friend

Nathan Oliveira assessed the Andersons' art holdings. Praising the paintings by Diebenkorn and David Park, he advised, "It is time to start considering possible changes in the collection (selling, buying, better examples, etc.)."[2] The Andersons followed Oliveira's advice, ushering in the 1970s with a flurry of exchanges. In 1970 they sold their paintings by Monet and Renoir, as well as paintings by Morris Louis, Mark Rothko, and Jackson Pollock that were not representative of the artists' best work.

Also in 1970 the Andersons hired their first collection manager. Together they developed a working plan that outlined long- and short-term acquisition goals; standards for the proper care, custody, and control of the art; objectives for facilitating art world relationships; and a plan to establish an educational program using their art. The collection they envisioned would be "comprehensive and international in scope" and would include "significant examples of noteworthy contemporary artists whose work and thought have given both force and direction to art in the present century."[3]

During this period a new addition, Clyfford Still's *1947-Y* (1947), an abstract painting made in California, signaled a turning point for the Andersons' collecting. Still's expressive paint handling relates *1947-Y* to the works by Willem de Kooning and Diebenkorn the Andersons already owned. But the painting also represents a school of Abstract Expressionism that was emerging on the West Coast in the late 1940s. The rigor and opacity of Still's painting, split by swift bursts or streaks of color, projected a new vision of Abstract Expressionism that linked the gesturalism of "action painting" to the austerity of Rothko's work, or what Harold Rosenberg called "idea painting."[4] Still fostered this "San Francisco School" of Abstract Expressionism through his teaching position at the California School of Fine Arts (now the San Francisco Art Institute). The purchase of *1947-Y* in 1972 inaugurated the Andersons' lifelong commitment to rigorous painterly abstraction—both its challenges and its rewards. They began to pursue more abstract work, including examples by artists already represented in the collection.

The acquisition of *1947-Y* also marked the Andersons' growing commitment to supporting artists living and working in California. They felt that original and important art was being made on the West Coast, work that had none of the provincial implications of the phrase "California art." As the collection grew throughout the 1970s, selections made their way to the walls of the Saga corporate headquarters.

The Andersons' presentation of their collection at Saga was intended as a means for community outreach. Working toward the educational goals they had outlined, they instituted an art library at Saga, lunchtime talks for employees, evening

lectures by local artists and art historians, and, of course, tours. "Perhaps the most important event in an educational program," they hoped, "would be the enlightenment for many people about the role fine arts play in our everyday lives."[5]

The Andersons also opened their doors to the arts community at nearby Stanford University where students of modern and contemporary art had easy access to the collection. They also cultivated a cadre of young arts professionals. Since 1975 twenty-seven Stanford students have interned at the Anderson Collection as a part of their undergraduate, studio, or graduate education. Further extending their outreach, the Andersons have given works of art to institutions throughout the Bay Area, including the Fine Arts Museums of San Francisco, the Oakland Museum of California, the San Jose Museum of Modern Art, and SFMOMA.

A focused and diligent pursuit of works by particular artists characterized the couple's acquisitions throughout the 1980s and 1990s. They sought out works of consequence by Clyfford Still, as well as by other artists who would soon become family friends, including Philip Guston and Frank Stella. The Andersons were continually drawn to works rife with tension between abstraction and figuration, but now they caught the artist in the process of experimenting. Free from the need to fill in a historical collection, they purchased only works of contemporary art, frequently choosing those that had yet to be recognized for their greatness. They continued to champion Guston while his work received poor reviews—ones that echoed the negative comments that had greeted Diebenkorn's earlier explorations of figuration and abstraction. The Andersons followed Guston's development and collected his work in depth, capping off their Guston suite with the magnificent *Coat II* (1977).

Much of this essay is drawn from Gary Garrels, "The Anderson Collection: An Introduction," and Rachel Teagle, "A Modern Touch: The History of the Anderson Collection," in *Celebrating Modern Art: The Anderson Collection*.

1. Unless otherwise noted, all quotations from Hunk Anderson come from conversations during the summer of 1999 with Rachel Teagle, former curator of the Anderson Collection.

2. Anderson artist file. The fact that Oliveira's *Pyramid on a Face* and *Woman's Face*, both of 1968, were the first works the Andersons purchased from a California artist gives a sense of his early influence.

3. "Working Plan," n.p. Anderson Collection Archives, 1970.

4. Thomas Albright, "Clyfford Still and Abstract Expressionism," in *Art in the San Francisco Bay Area, 1945–1980: An Illustrated History* (Berkeley and Los Angeles: University of California Press, 1985), 24–26.

5. "Working Plan," n.p. In 1983, for example, Albert Elsen, Tom Holland, Joe Zirker, and Dorothy Goldeen lectured on topics such as the state of contemporary art, how to begin acquiring contemporary art, and the process of printmaking.

Similarly, the Andersons befriended Frank Stella and purchased a work from each of his major exhibitions throughout the 1980s. Adding these to the excellent examples of Stella's previous work they had already acquired, the breadth of their Stella holdings amounts to a concise retrospective of the artist's career.

The Andersons' daughter, Mary Patricia ("Putter") Pence, urged her parents toward a more contemporary bent in their collecting in the 1980s and 1990s. Putter grew up surrounded by art in her parents' home. Family visits to exhibitions and studios became a kind of game; each player would come away with three choices to compare with the others' selections. Putter's lifelong love of art led her to open the Pence Gallery in Santa Monica, California, where she refined her own definition of modern art to include work by many younger artists. Her sophisticated eye would leave its mark on her parents' collection; she acted on the Andersons' behalf in purchasing a number of works from Southern California galleries.

During the 1980s, as Putter's fieldwork and new friendships afforded the Andersons greater access to new art, they gradually sold off the remaining paintings that no longer fit with the others. Like the working style of the artists they admired, the Andersons' collecting became more layered and nuanced and they confidently display the evidence of past experimentation. The resulting collection is a tribute both to the artists who have expressed the complexities of our times and to the Andersons, who have followed a visionary journey, seeking out the new and building a context within which to display it.

A glance at their home makes it clear that the Andersons surpassed Oliveira's advice and formed a collection with a unique and important identity. From the living room one can see works by Alexander Calder, Morris Louis, Jackson Pollock, Auguste Rodin, David Smith, and Clyfford Still hung in a California ranch house filled with English antiques. Their home embodies a desire to bring together East and West Coast, old and new—an attitude that perfectly reflects the couple's approach to collecting art.

The Andersons have taken great joy in all the works of art they have gathered together. "Each painting," Hunk says, "has been an event in our lives, and luckily they've always been happy events." This exhibition represents for the Andersons the culmination of these happy events, bringing the largest group of works from the collection to its broadest audience. *Celebrating Modern Art: The Anderson Collection* gives museum visitors an opportunity to renew our appreciation of the achievements of art in the twentieth century and, as we enter a new century, to reassess our understanding of art's pleasures, challenges, and place in our lives.

PLATES

with texts by

JANET BISHOP

JULIA BRYAN-WILSON

MARTIN FOX

MOLLY HUTTON

RACHEL TEAGLE

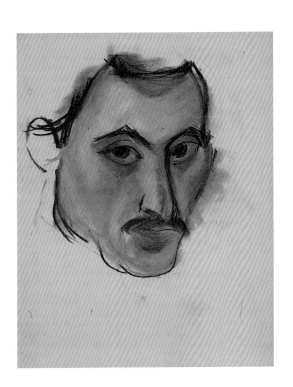

ARSHILE GORKY
Self-Portrait, 1926
pastel and graphite on paper
14¼ x 11¼ in.

HEAD OF A WOMAN

EMIL NOLDE

Born in northern Germany in 1867, Emil Nolde strove to invent a pictorial style that combined the traditions of late medieval German art and the self-consciously "primitive" forms of modern painting. Although he is categorized with the German Expressionist movement Die Brücke, Nolde was only very briefly formally affiliated with this group, preferring to travel his own idiosyncratic path. "Intellectuals and literati call me an expressionist," he once complained. "I do not like this classification. A German artist, that I am."[1] Indeed, his strident nationalism led him to join the Nazi party in 1920, although to his dismay the party never accepted his art. Quite the opposite: Nolde's work, scorned as childish and crude, was exhibited in the 1937 *Degenerate Art* show.

A self-taught artist, Nolde created impassioned works with raw, bold handling. He painted many watercolor portraits and character sketches, often with vivid, unrealistic tones. Nolde's excellent color sense is demonstrated in *Head of a Woman*. It is a lush, vibrant portrait whose dissolving swaths of color come together to articulate the features of a woman. The brilliant cobalt blue background provides a rich contrast to the striking gold highlights on the woman's forehead and cheek. Her sensuous mop of dark hair, pulled back to emphasize her high forehead, is shot through with light yellow rivulets. Punctuating the face is a single bright green nostril.

Nolde painted quickly, using dampened absorbent paper that allowed the pigments to run into each other and saturate the fibers. This highly improvisational wet-on-wet method creates the bleeding colors that give the woman a haunting, enigmatic expression. Her inky, impenetrably dark eyes rimmed by lavender and blue stare out at the viewer. She turns her head as if to engage the beholder, yet her full red mouth is ambiguously set between a small smile and absolute neutrality. Her defined, crimson lips seem to float or hover above the delicate, melting washes of the face. The sunken eyes have a masklike quality; Nolde had become interested in ritual masks during a pivotal trip to the South Seas in 1913.

In *Head of a Woman*, the colors vibrate: the hot orange at the woman's neckline pulses next to the fluid purple of her shoulder and neck. Nolde believed in the mystical qualities of color; he imbued his hues with a symbolic meaning. For him, the perception of color communicated more intensely and immediately than other sensory experience. As the art historian Peter Selz has written, Nolde "endowed watercolor with a new life and vitality and a sheer visual beauty which places him in the top mark of modern artists."[2]
— JBW

EMIL NOLDE
Head of a Woman, ca. 1920s–30s
watercolor on paper
18⅞ x 13⅞ in.

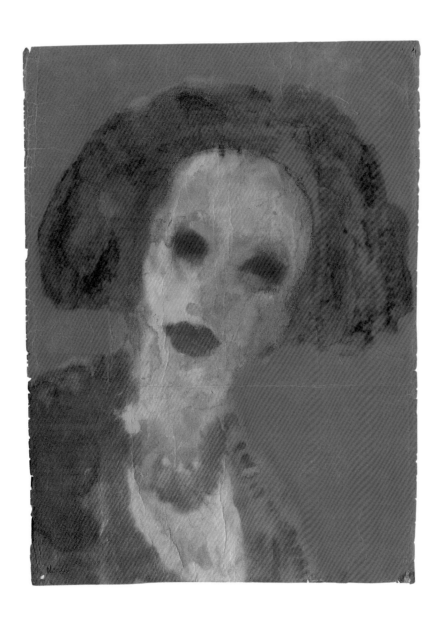

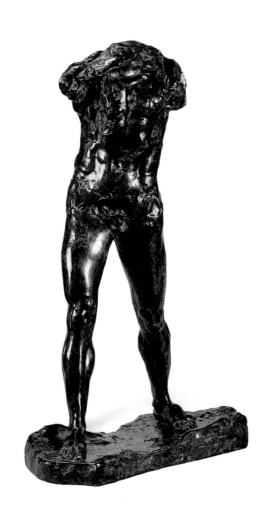

AUGUSTE RODIN
Walking Man, 1880–85
bronze
33⅛ x 23½ x 10⅝ in.

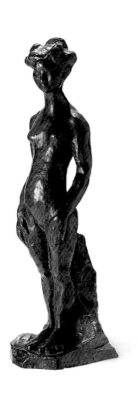

HENRI MATISSE
Standing Nude, 1906
bronze
19 x 4⅞ x 6⅝ in.

MAN IN THE OPEN AIR

ELIE NADELMAN

Born in Warsaw, Elie Nadelman was forced by World War I to immigrate to New York after spending ten years in Paris. *Man in the Open Air*, first exhibited in Alfred Stieglitz's pioneering 291 gallery, synthesized the traditions of European modernist sculpture, classical statuary, and American folk art.

The figure's body is composed of harmonious, tapering curves derived from the sculptor's modernist concern for abstract form. According to a statement Nadelman made in Stieglitz's journal, *Camera Work*: "It is form in itself, not resemblance to nature, which gives us pleasure in a work of art. . . . I employ no other line than the curve, which possesses freshness and force. I compose these lines so as to bring them in accord or opposition to one another."[1]

The pose of *Man in the Open Air* parodies the classical sculptural tradition. The attenuated form of the tree refers to the trunks needed to support the heavy weight of standing figures in Roman marble sculpture. Unnecessary here because bronze supports its own weight, the tree pierces the figure's right arm rather than holding it up.[2] Instead of classical nudity, Nadelman's *Man* wears a bowler hat and a string bow tie, underscoring his dapper modernity. This is a modernity that seems to be in good-spirited harmony with nature, rather than cramped by urban life or threatened by the mechanized violence of the war in Europe that Nadelman had escaped.

Man in the Open Air's proportions, with its diminutive height, small head, and unarticulated muscles, are similar to the forms found in handcrafted toys and dolls. This toy-like appearance was derived in part from Nadelman's interest in folk art, which he and his wife avidly collected.[3] They owned thousands of folk art objects, including toys, dolls, furniture, paintings, and sculpture by artists without academic training. Folk art traditionally had been categorically excluded from the fine arts. Nadelman's serious consideration of this populist tradition is an example of an artist knowingly looking outside accepted artistic traditions for inspiration, then incorporating aspects of those traditions into his work to ground his modernism in stylistic precedent. —MF

ELIE NADELMAN
Man in the Open Air, 1914–15
bronze
51¼ x 23¼ x 10⅞ in.

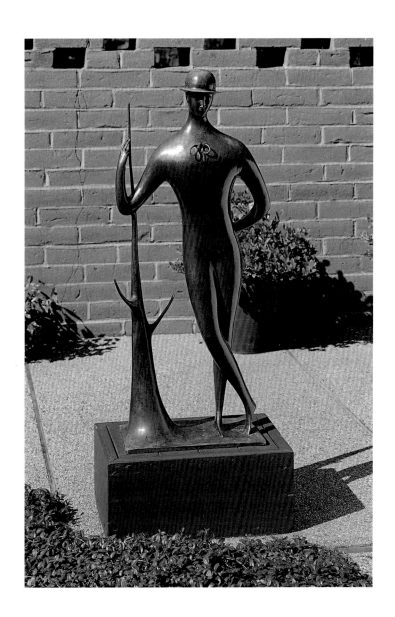

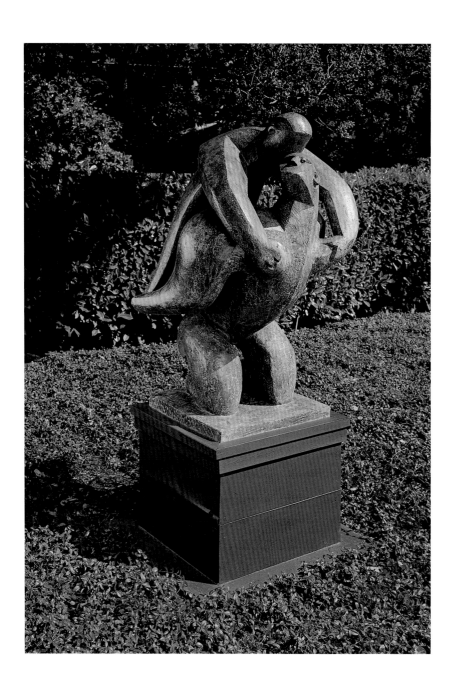

JACQUES LIPCHITZ
Mother and Child, 1930
bronze
55⅛ x 35⅛ x 34¾ in.

opposite:
JOEL SHAPIRO
Untitled, 1983–84
bronze
78⅜ x 80½ x 39 in.

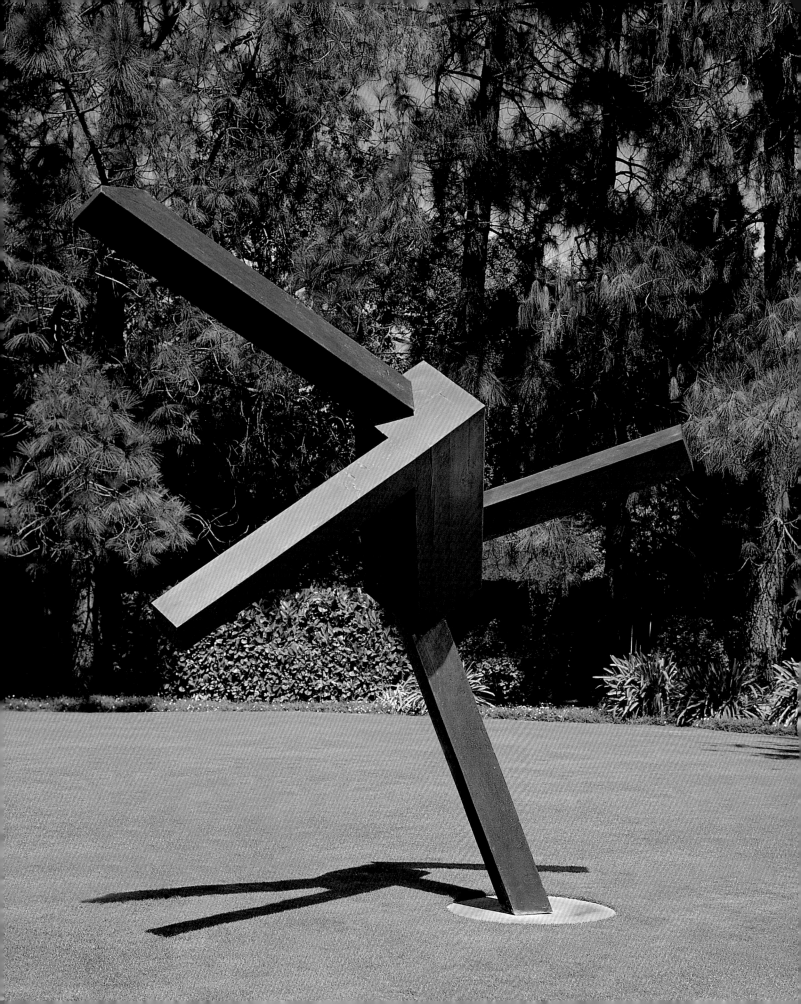

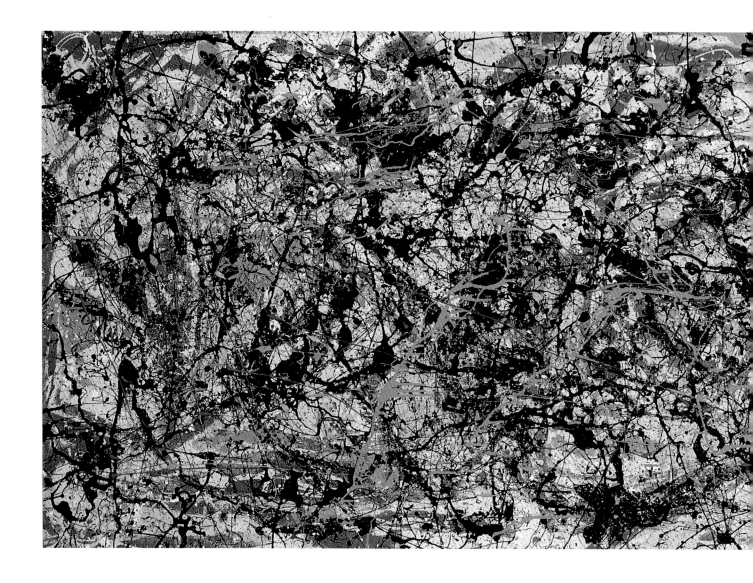

LUCIFER

JACKSON POLLOCK

Jackson Pollock's reputation as one of the most innovative painters in the history of American art is anchored in the works he created in the period from 1947 to 1951. It was during this interval that Pollock freed the canvas from the confines of a stretcher by placing it on the floor of his rural Long Island studio. Here, Pollock began his series of original and remarkable "drip paintings," of which *Lucifer*, dating from 1947, is one of the earliest and most significant.

Modest in size when compared with some of Pollock's later, mural-size drip paintings, *Lucifer* is one of a group of works the artist envisioned as occupying an intermediate state in the evolution of painting. "I intend to paint large movable pictures which will function between the easel and the mural. . . . an attempt to point out the direction of the future, without arriving there completely."[1] By tacking the canvas directly to the floor, the artist could move freely around the work, and Pollock quickly adopted the technique of pouring fluid enamel paint straight from the can or dripping it from sticks

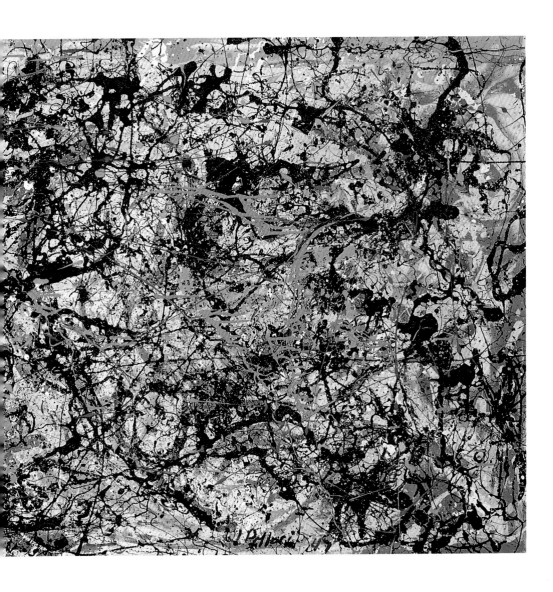

and brushes. In the case of *Lucifer*, tadpolelike shapes in yellow, red, orange, and purple were created by squeezing paint directly from a tube onto an underlying layer of brushwork. The delicate lines of tracery and layers of color in *Lucifer*, seemingly applied spontaneously and by chance, were in fact possible only because Pollock maintained a rigorous control of his medium. Although the work was painted on the floor like the other drip paintings, Pollock seems to have held the painting upright toward the end of the process before applying the final color—green. As if suspended in animation, these last drips generate a sense of movement, a sort of windswept atmosphere that stands in contrast to the more controlled marks beneath them.

Pollock, who was "very fond of this painting," refused an offer of $1,000 for *Lucifer* in 1950, suggesting that a more appropriate price would be $1,600. Although Pollock was unable to secure his asking price at the time it is easy to see why he might have so valued the painting, for it is a virtuoso work distinct in the artist's oeuvre. —MH

JACKSON POLLOCK
Lucifer, 1947
oil and enamel on canvas
41 3/16 x 105 1/2 in.

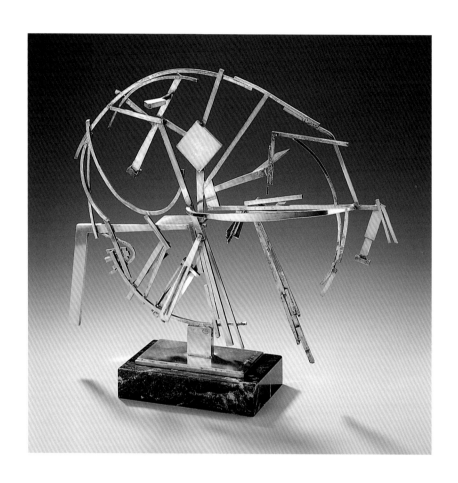

DAVID SMITH
Timeless Clock, 1957
silver
20⅜ x 26 x 6½ in.

ROBERT MOTHERWELL
Joy of Living, 1948
oil, ink, and collage on paper
30 x 24 in.

GANSEVOORT STREET

WILLEM DE KOONING

Willem de Kooning, who immigrated to the United States from the Netherlands in 1926, was one of the key artists involved in the development of American Abstract Expressionism as it evolved in New York in the 1940s and 1950s. De Kooning is perhaps best known for his *Women* series, executed between 1950 and 1955. During several periods of his career, however, he was just as intensely involved in abstracting the larger world around him, in particular, the urban environment in and around Manhattan. During the mid- to late forties, de Kooning produced a group of paintings, many in black and white, that, although they contain definite references to the human body, are extremely complex combinations of biomorphic forms and paraphrased landscape details. The artist's gestural use of line, executed rapidly yet confidently, resulted in ambiguous shapes that appear both partially representational and wholly abstract.

Gansevoort Street is one of a small group of paintings from this period that are exceptions to the artist's engagement with black and white. The painting's red-orange palette serves a distinct representational function. Running through the heart of New York's bustling meat-packing district, the actual street named Gansevoort was then (as today) home to a variety of wholesale meat butchers and distributors, the sometimes grisly evidence of which would have greeted any visitor to the area. De Kooning's expressive use of raw, fleshlike colors, therefore, forcefully transports the viewer into the neighborhood, the artist's addition of white and black paint suggesting bones.

Although primarily a work of abstraction, traditional landscape elements can be detected throughout *Gansevoort Street*, particularly in the houselike form highlighted with yellow paint in the lower center of the painting and the slightly more abstracted structural form in the upper left corner. Similarly, the sinuous lines and curves found in the upper left quadrant call to mind the serpentine line the artist often used to delineate the human form in both his earlier and later more representational images. Like his other paintings from this period, *Gansevoort Street* is the product of de Kooning's fascination with New York and his preoccupation with the visual stimuli that engulfed him during his walks through its streets. De Kooning would remark of his own strain of abstraction, provoked by the external materials that entered, sometimes arbitrarily, into his field of vision: "Everything that passes me I can see only a little of, but I am always looking. And I see an awful lot sometimes."[1] This interest in landscape and details of the city environment would reemerge in de Kooning's urban-themed works of the mid-1950s, however none of the later works quite attain the same level of poetic visual interest achieved by the abstract landscapes, in particular, the powerful *Gansevoort Street*. —MH

WILLEM DE KOONING
Gansevoort Street, 1949–51
oil on cardboard
30 x 40 in.

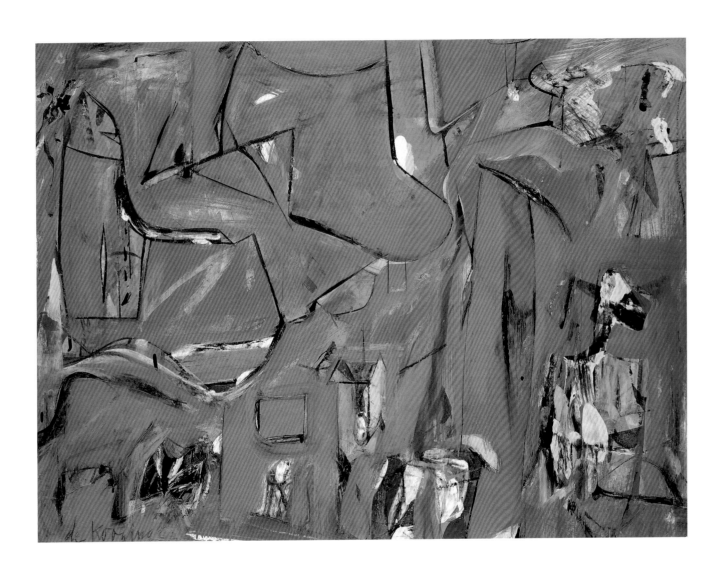

FIGURE 8

FRANZ KLINE

With its large scale and immediate visual impact, *Figure 8* suggests spontaneous and unrestrained motion, as if it had been produced by a single, complex gesture of arm and brush. Kline here limited himself to a palette of black and white, maximizing the contrast of colors and dynamic tensions in his work. The tautness of the painting's looping forms competes with the tendency for the shapes to explode outward. This dynamic show of gesture makes it a prototypical example of *action painting*, a term coined by the critic Harold Rosenberg in 1952, the same year in which Kline painted *Figure 8*. According to Rosenberg, "What was to go on to the canvas was not a picture but an event."[1] Rather than execute a preconceived composition, action painters such as Franz Kline, Willem de Kooning, and Jackson Pollock were said to improvise with their materials, leaving the final painting as a record of their process.

Further inspection, however, reveals *Figure 8* to be systematically constructed so as to give the impression of a single action. Its forms were not the result of one gesture but were built up in a methodical fashion. Kline painted white over black as well as black over white, at times allowing intermediary shades to show through. There is a disparity, then, between the carefulness of the painting's construction and the force of its immediate impact. As with other improvisatory art forms, such as jazz or modern dance, spontaneity requires a framework of developed style and structure to emerge and to be recognized. — MF

FRANZ KLINE
Figure 8, 1952
oil on canvas
80⅞ x 63⅜ in.

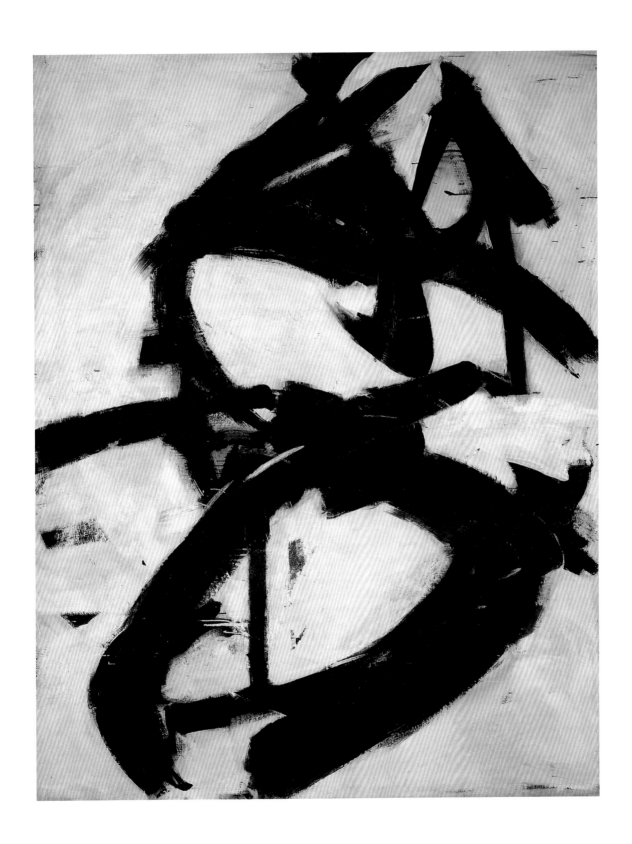

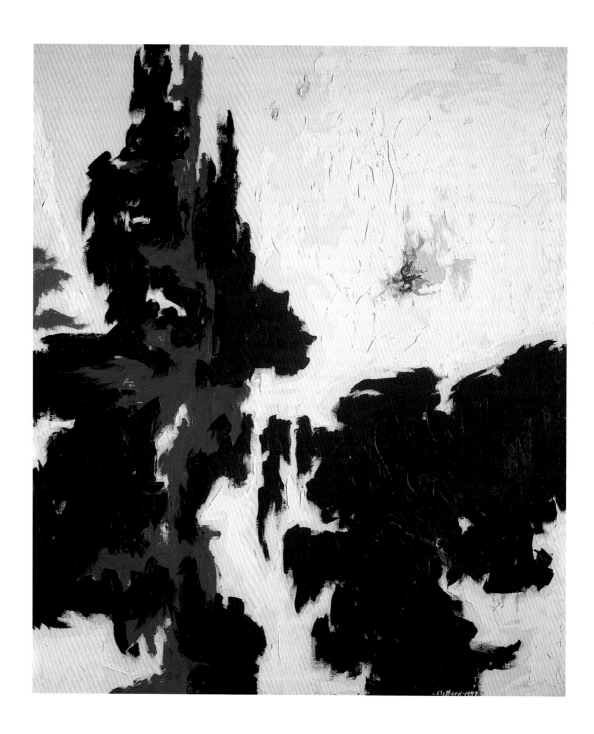

CLYFFORD STILL
1947-Y, 1947
oil on canvas
68½ x 59 in.

opposite:
SAM FRANCIS
Red in Red, 1955
oil on canvas
78⅜ x 78⅜ in.

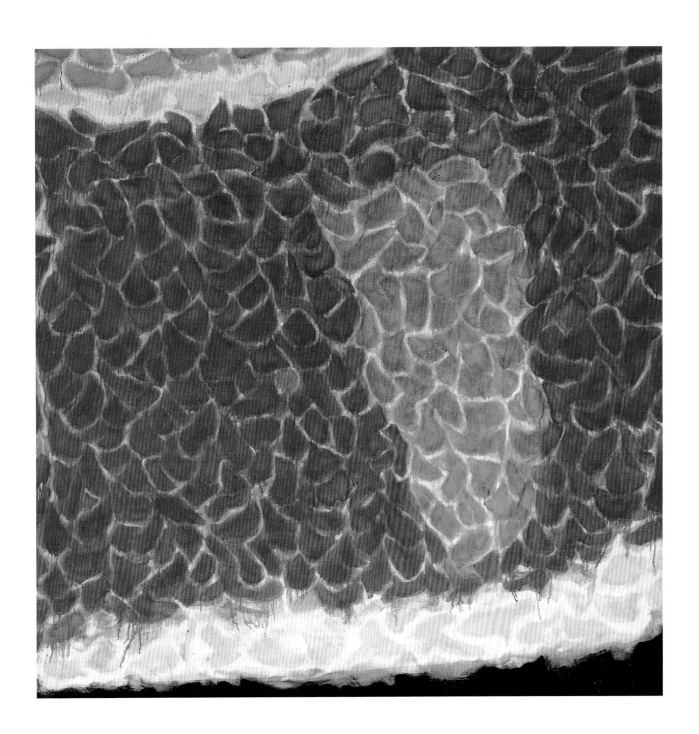

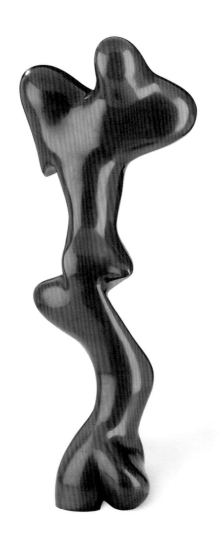

JEAN (HANS) ARP
Croissance (Growth), 1938
bronze
42½ x 17½ x 10¼ in.

ELLSWORTH KELLY
Black Ripe, 1955
oil on canvas
63³⁄₁₆ x 59⅜ in.

THE INVISIBLE OBJECT (HANDS HOLDING THE VOID)

ALBERTO GIACOMETTI

A pivotal sculpture in Alberto Giacometti's career, *The Invisible Object* marks a transition from a surrealist mode dedicated to evoking extreme psychological states toward his later style centered on the perception and rendering of bodies. Here, a female figure is fused with a structure resembling a nonsupportive chair which also suggests a cage dividing her from our space. Giacometti used the title *Hands Holding the Void* alternately with *The Invisible Object*. Although these titles contradict one another, they both point to the same absence—the figure's hands are positioned in an ambiguous gesture suggestive of holding, but lacking any concrete object. This gesture is coupled with the blank panel obscuring her lower legs and a bird's head emerging from her support. The opposition between an implied absence and impossible presence results in an uncanny strangeness, which is accentuated by the figure's masklike face and her thin, smooth body.

The surrealist André Breton wrote that the figure's head was inspired by a World War I–era protective mask Giacometti found at a flea market.[1] Others have suggested that this work's totemic character and pose were derived from sculptures from the Solomon Islands which the sculptor might have seen.[2] Giacometti combined the surrealist interests in psychologically charged objects, inspiration from found materials, and admiration of Oceanic art with a stylistic shift toward the depiction of the whole human figure. *The Invisible Object* anticipates the sense of isolation and elongated physique characteristic of his later work, which would grow out of Giacometti's attempts to reconcile the process of seeing with the process of modeling. —MF

ALBERTO GIACOMETTI
The Invisible Object
(*Hands Holding the Void*), 1934
bronze
60¼ x 12¾ x 11 in.

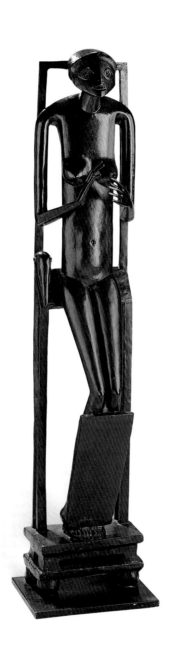

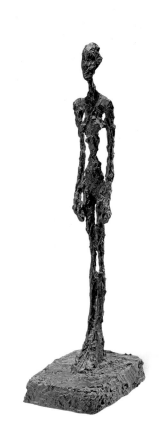

ALBERTO GIACOMETTI
Standing Figure, 1957
bronze
27¼ x 7 x 9 in.

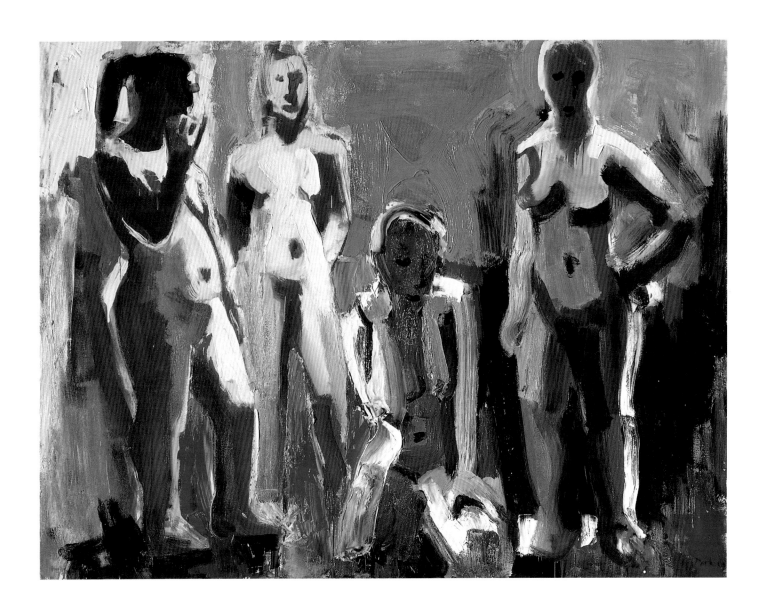

DAVID PARK
Four Women, 1959
oil on canvas
57 x 75⅜ in.

GIRL ON THE BEACH

RICHARD DIEBENKORN

After establishing himself as an accomplished abstract expressionist, Richard Diebenkorn switched to a figurative style in 1955, following the example of his colleagues and former teachers at the California School of Fine Arts, David Park and Elmer Bischoff. These artists' turn to the figure was radical because abstract painting dominated critical discussion and artistic practice at the time. Although many American painters began to reverse the modernist tendency toward greater abstraction in the 1950s, the Bay Area became a center for artists who were informed by the methods and concerns of Abstract Expressionism but chose to apply these techniques to figurative subjects.[1]

In 1957 Diebenkorn expressed his disillusionment with the rhetoric and process behind Abstract Expressionism: "I came to mistrust my desire to explode the picture and super-charge it in some way. At one time the common device of using the super emotional to get 'in gear' with a painting used to serve me for access to painting, but I mistrust that now."[2] Behind this appraisal was an understanding that abstract painting, in the absence of recognizable subject matter, offered a direct expression of the artist's personality. Figurative imagery allowed him to anchor his paintings to subjects other than himself while simultaneously developing his unique style. "I think what is more important," Diebenkorn qualified, "is a feeling of strength in reserve—tension beneath calm."[3]

Girl on the Beach demonstrates Diebenkorn's grappling with the depiction of real objects while further developing the painterly devices of his earlier abstract expressionist painting. He placed his female model within a space that exists simultaneously as flat bands of color and as a landscape of sand, sea, and sky. While defining his figure's form, the paint handling equally emphasizes the process of constructing and revising the painting so as to activate its surface. The painting's colors represent the effects of the bright sun, but their limited palette is still related to Abstract Expressionism.

The delineation of the model's facial features is sacrificed for what the painter described as "a painting wherein the shapes, including the face shape, worked with the all-over power I came to feel was a requisite of a total work."[4] The painting juxtaposes compositional coherence with a formal and psychological emphasis on the model. She is represented as solid and fully formed despite the lack of anatomical articulation, which tends to emphasize her shape while simultaneously appearing as evidence of the painting process. There remains a balance between the representation of a woman absorbed in her reading and Diebenkorn's attention to the materiality of paint and the process of its application. —MF

RICHARD DIEBENKORN
Girl on the Beach, 1957
oil on canvas
52⅛ x 57¼ in.

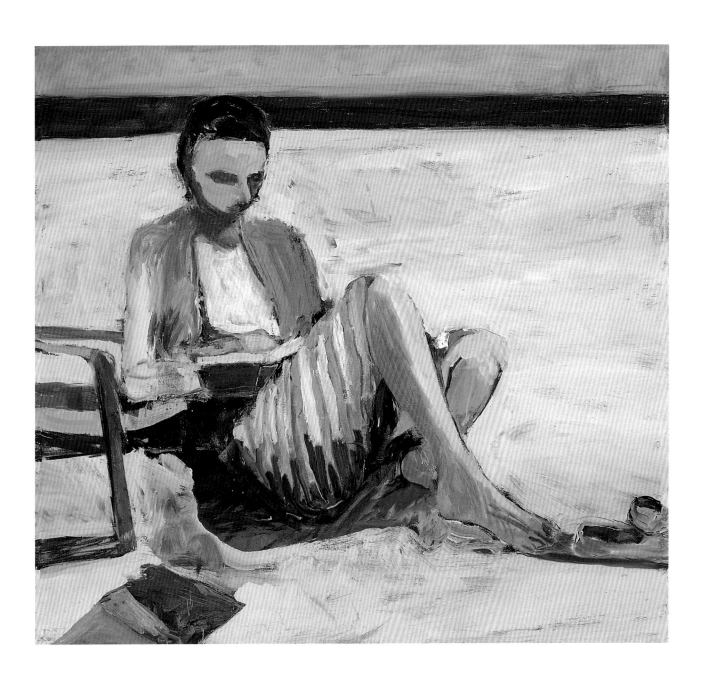

LAND'S END

JASPER JOHNS

By 1963, when Jasper Johns painted *Land's End*, he had moved away from the iconic targets and flags that had been so germinal in the development of Pop art. In those works the artist had presented "things the mind already knows,"[1] whereby the artwork's composition was fully dictated by the object, leaving the artist room to investigate other aspects of painting (the subject of the work not really being the object at all). In *Land's End*, despite the use of the words *red*, *yellow*, and *blue*—poets' names for painters' tools—the stenciled application does little to mask their very personal and metaphoric use. Johns not only reclaims the abstract expressionists' emotional, turbulent brushwork in the painting, but his rendering of each of the three words upsets the viewer's/reader's expectations of how they should be: YELLOW is painted in blue, random letters that appear to be flopping or slipping off the canvas; RED is duplicated by a mirror image; and the letterspacing of BLUE is irregular and agitated. Only the small RED, rendered in fire-engine red atop the larger version of the same word, appears perfect and pure. The central mark on the canvas is an arm that ends with the imprint of Johns's own right hand, upwardly reaching, striving for the perfect red, gasping as a drowning figure would for the only part of the canvas with any "air"—the stained but not painted portion of the upper third, the area above the horizon line.

Johns called the painting *Land's End*, he has said, "because I had the sense of arriving at a point where there was no place to stand."[2] In this and other works from the same period such as *Periscope (Hart Crane)* and *Diver*, Johns appears to identify with Crane, the poet who died by drowning in 1932. The artist's hand reaches upward, but the drawn arrow points back down. He is struggling for air, but the outcome is uncertain. Everything, Johns has said, was "confused with thought" in this complex, emotionally charged canvas. —JB

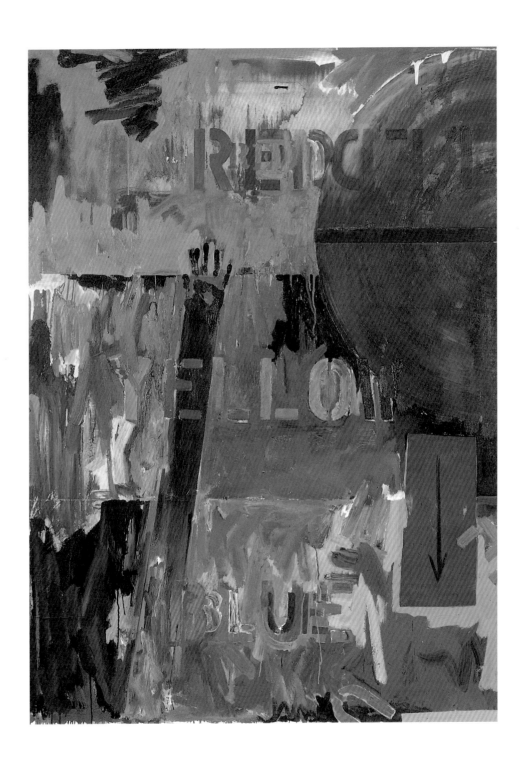

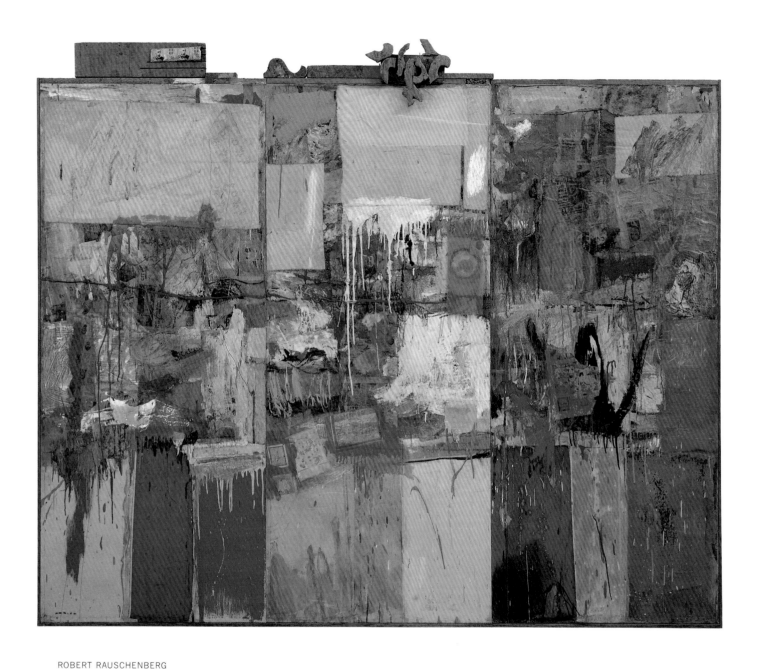

ROBERT RAUSCHENBERG
Collection (formerly untitled), 1954
oil and aqueous paint, lacquer, and resin
with diverse collage elements (including
fabric, paper, metal, wood, and a mirror)
mounted on three joined canvases
80 x 96 x 3½ in.
San Francisco Museum of Modern Art,
Gift of Harry W. and Mary Margaret
Anderson

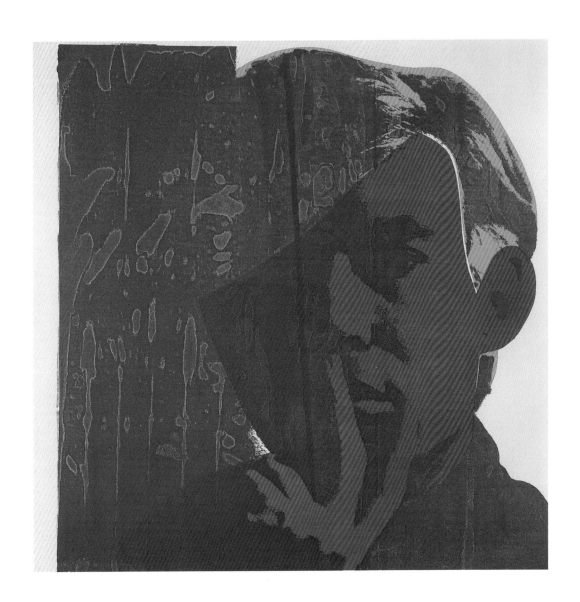

ANDY WARHOL
Self-Portrait, 1967
synthetic polymer paint and
silkscreen ink on canvas
72¼ x 72¼ in.
San Francisco Museum of Modern Art,
Gift of Harry W. and Mary Margaret
Anderson

ROY LICHTENSTEIN
Rouen Cathedral Set V, 1969
oil and acrylic on canvas
3 panels, each 63⅛ x 42⅛ in.
San Francisco Museum of Modern Art,
Gift of Harry W. and Mary Margaret
Anderson

CANDY COUNTER

WAYNE THIEBAUD

Candy Counter shows sweets ready to be sold and consumed. Focusing on the way in which these sugary confections are displayed, Wayne Thiebaud has suggested their look and textures in a way that urges us to consume his painting visually. *Candy Counter* presents us with a theatrical space in which only the display case and its contents are visible; gone are the sounds, smells, and tastes of a candy store.

Thiebaud has discussed his interest "in the way in which we ritualize food, play around with it."[1] The artificiality of candy makes it a highly ritualized food, in which visual presentation is as important as taste. He paid careful attention to the painterly nature of frosting and to the harsh effects of neon light on the products and their shadows. The arrangement of goods is compositionally nonhierarchical, so that all are equally prominent, all equally available for purchase.

The execution of *Candy Counter* coincided with the emergence of Pop art. Like the Pop artists, Thiebaud was concerned with the aesthetics of commercial display in contemporary American society. However unlike Pop, which often investigated the means and effects of mechanical reproduction, he accentuated the handmade nature of both his painting and its subject matter.

Thiebaud's work is also tied to the tradition of still-life painting, which takes ordinary objects as its subject. As such, still lifes are indicative of what a culture makes use of, holds as important, or considers to be banal. This contemporary still life suggests both the abundance and artificiality of American habits of consumption. —MF

WAYNE THIEBAUD
Candy Counter, 1962
oil on canvas
55⅛ x 72 in.

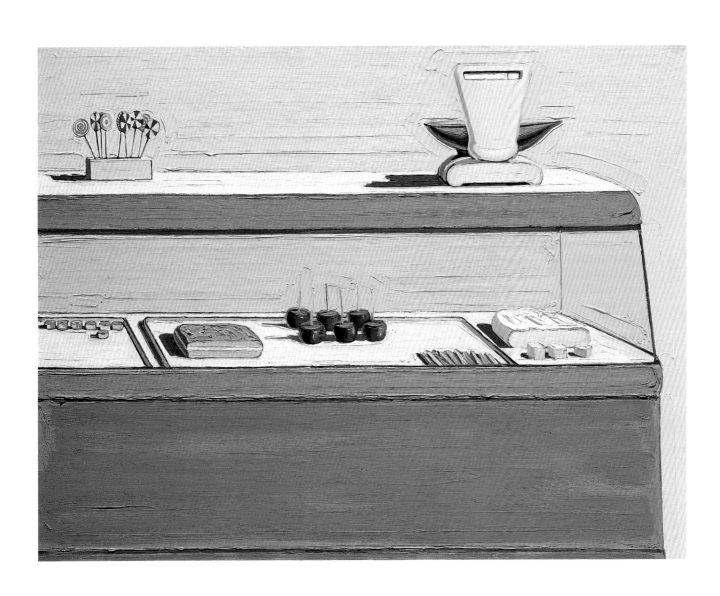

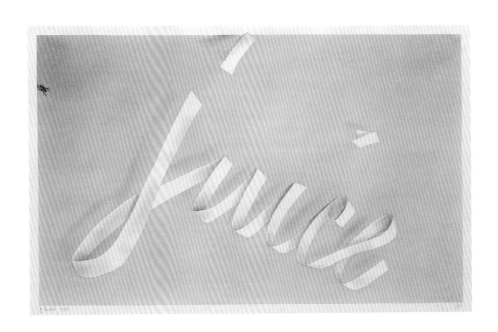

ED RUSCHA
Juice (formerly *Liquid with Fly*), 1967
gunpowder on paper
14⅜ x 22⅞ in.

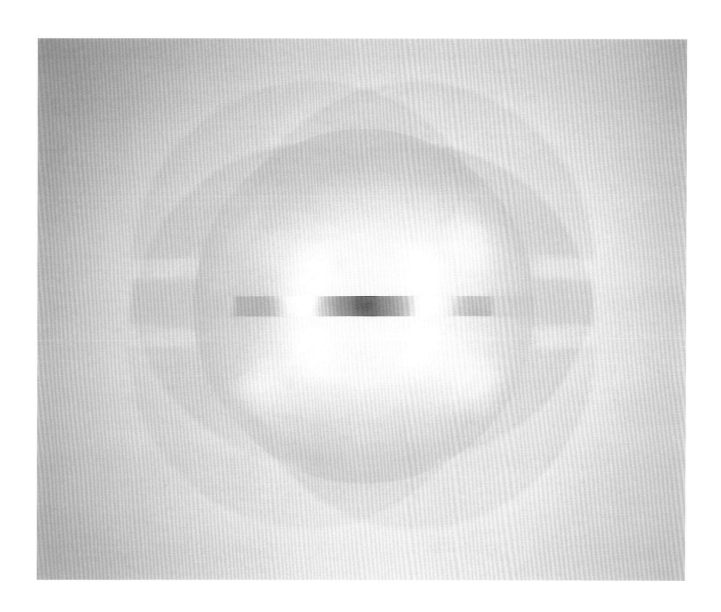

ROBERT IRWIN
Untitled, 1969
acrylic lacquer on cast acrylic
53 x 53 x 24½ in.

WINDOW

PHILIP GUSTON

In 1970 Philip Guston shocked the art establishment by exhibiting works radically different from his earlier, abstract expressionist style. Although he had found success as an action painter, along with his high school friend Jackson Pollock, Guston alienated the art world by renouncing the hermeticism of abstraction. He claimed, "There is something ridiculous and miserly in the myth we inherit from abstract art that painting is autonomous, pure and for itself."[1] Guston instead turned toward the figure, creating narrative, cartoonlike images with controversial subjects: "I got sick of all that purity! Wanted to tell stories."[2] These new paintings were topical and polemical, with caricatured hooded Ku Klux Klansmen parading around bleak cityscapes.

Guston (born Philip Goldstein) was committed to the ethics of painting and representation. Deeply concerned with racist and anti-Semitic agitation, Guston had an obsession with the Ku Klux Klan, which appears in some of his juvenilia. The Klan resurfaced in his art during the Vietnam War: "In 1967–68, I became very disturbed by the war and the demonstrations. They became my subject matter and I was flooded by a memory. When I was about 17–18, I had done a whole series of paintings about the Ku Klux Klan, which was very powerful in Los Angeles."[3] The bulky, faceless men are presented as menacing yet absurd as they wear masks to escape accountability for their actions. The hooded men are loaded and powerful symbols, but Guston avoids making them into simple scapegoats. "They are self-portraits. I perceive myself as being behind the hood."[4] What is remarkable in the Klan images is their restlessness—they refuse to name a clear enemy. Everyone, including the artist, is implicated. Guston's satire is laced with a nervous fascination with the overstuffed Klansmen, and these works evoke a lacerating, revelatory laughter.

Window was exhibited in the landmark 1970 show that announced Guston's shift in style and subject matter. It contains many of Guston's signature icons—window shade, hooded figure, blocky buildings, lit cigar. *Window*'s assured graphite marks show the mastery of an expert draftsman; Guston's lines are confident and sure, from the stitching of the hood to the shading of the puffy fingers. The clear, bold strokes demonstrate Guston's constructive, workmanlike attitude toward art making.

As a child Guston drew avidly and mimicked the styles of his favorite comics such as *Krazy Kat*, and this influence is evident in his late works. *Window* depicts a character frozen in action, as if it is one panel sheared from a comic strip. The pointed finger, a key motif in Guston's work, is arrested here like a still from a film. Who or what is being pointed to? Who is being accused or signaled? The drawing, like the mouthless figure, remains mute, assertive, challenging. —JBW

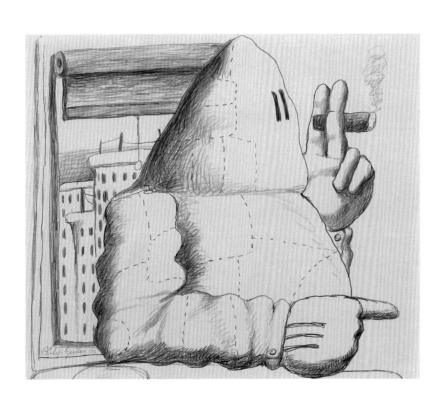

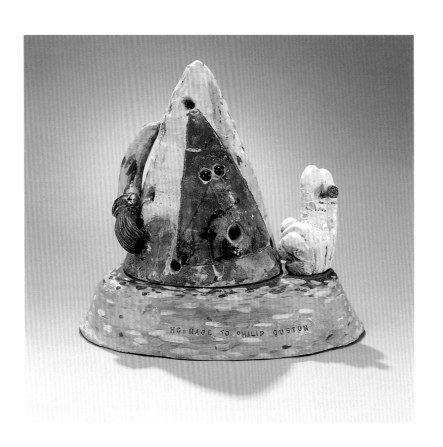

ROBERT ARNESON
Hommage to Philip Guston, 1981
glazed ceramic
18⅜ x 17⅛ x 14⅜ in.

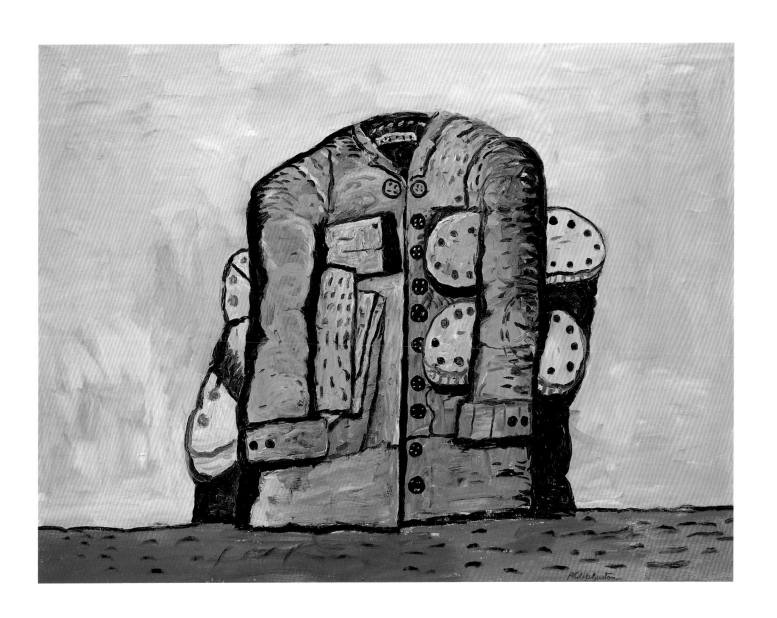

PHILIP GUSTON
The Coat II, 1977
oil on canvas
69⅛ x 92⅛ in.

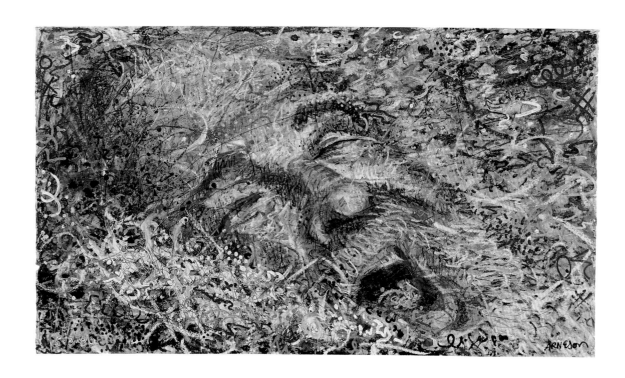

ROBERT ARNESON
Drawing for Ikarus, 1980
acrylic, oil stick, crayon,
and pastel on paper
30 x 52⅝ in.

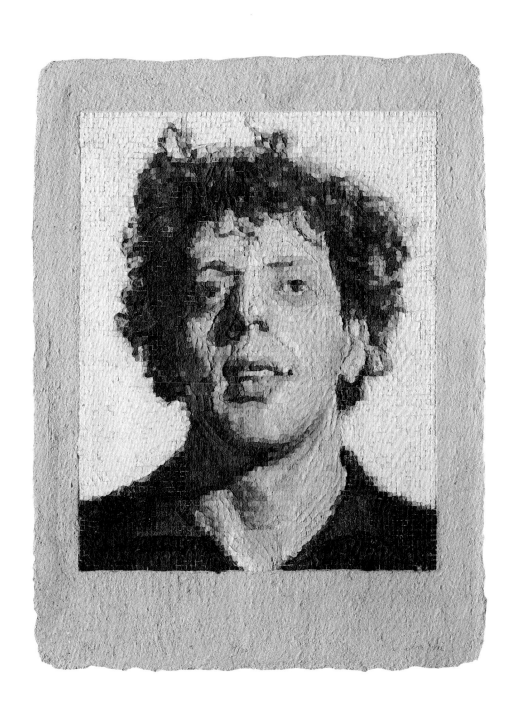

CHUCK CLOSE
Phil/Manipulated, 1982
pigment in paper pulp
68¾ x 52⅞ in.

THE 5TH NEVER OF OLD LEAR

JESS

Because his works often appropriate imagery from the broadest possible spectrum of available visual culture, including sources not normally identified with high-art production, Jess is sometimes associated with the American Pop art movement. Although clearly sympathetic to the Pop aesthetic, the works produced by Jess over a period of almost fifty years are simply too disparate and idiosyncratic to fit into any one category. For instance, in the group of works he calls "Paste-Ups"—collages in the tradition of those of the surrealists and dada artists, in particular the works of Max Ernst—Jess combines hundreds of fragments of images culled from such diverse sources as popular magazines, comic strips, and eighteenth- and nineteenth-century engravings.

In *The 5th Never of Old Lear*, the artist brings together a somewhat confusing yet hauntingly poetic group of vignettes, whose juxtapositions demand the viewer make his or her own metaphorical connections between the narrative elements. The title of the work refers to the figure of the bearded man at top center, who gestures wildly with his outstretched arm. This figure (along with three others that surround him) was taken from an eighteenth-century engraving made after the monumental 1788 Shakespearean painting *King Lear in the Storm*, by the American artist Benjamin West. The scene shows King Lear battling both the violent natural elements and what he realizes to be his own imperfect psyche.

Juxtaposed to this literary subject matter are images of strange machinery and curious technological devices with which human figures interact. Mechanical and scientific references are common in Jess's works, perhaps reflecting the artist's early technical training as a radiochemist.

Careful layering of the collage elements combined with the projecting surface of the work produces a powerful three-dimensional effect. This effect is heightened by the addition of the butterfly (just right of center) that raises one of its wings into the viewer's space.

Jess's paste-up working process is particularly time-consuming. Sometimes it takes months, or even years, for him to complete a work, first scouring thrift stores and antiquarian bookshops for images and then pinning the fragments and layers into place. According to the artist, "I'm always out shopping. I make tours of all the possible shops for old materials quite often. . . . I go out to have things see if they connect with me. . . . I don't go looking for things."[1] By embracing the role of chance and fortuity in his constant search for interesting subject matter, Jess produces works that could only be the product of a singular, particularly open, and receptive artistic mind. —MH

JESS
The 5th Never of Old Lear, 1974
paper collage
33⅛ x 27¹⁵⁄₁₆ in.

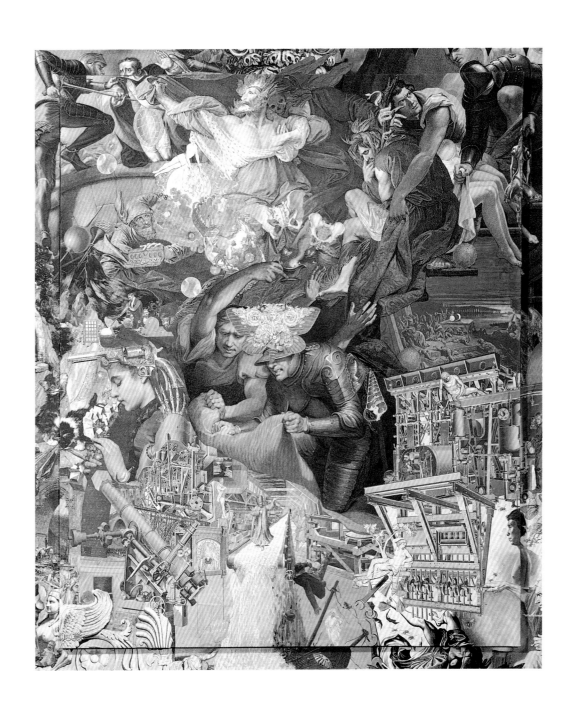

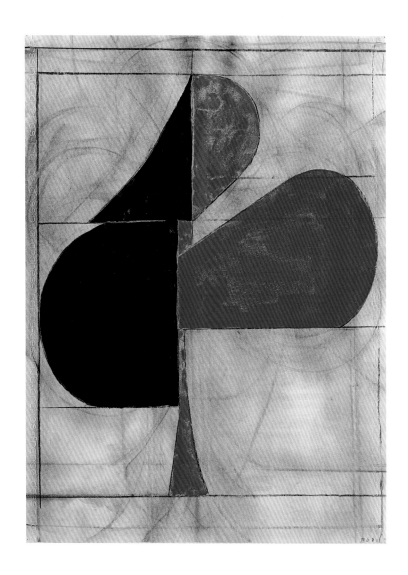

RICHARD DIEBENKORN
Untitled #9, 1981
gouache and charcoal on paper
30 x 22⅛ in.

opposite:
RICHARD DIEBENKORN
Ocean Park #60, 1973
oil on canvas
93 x 81¼ in.

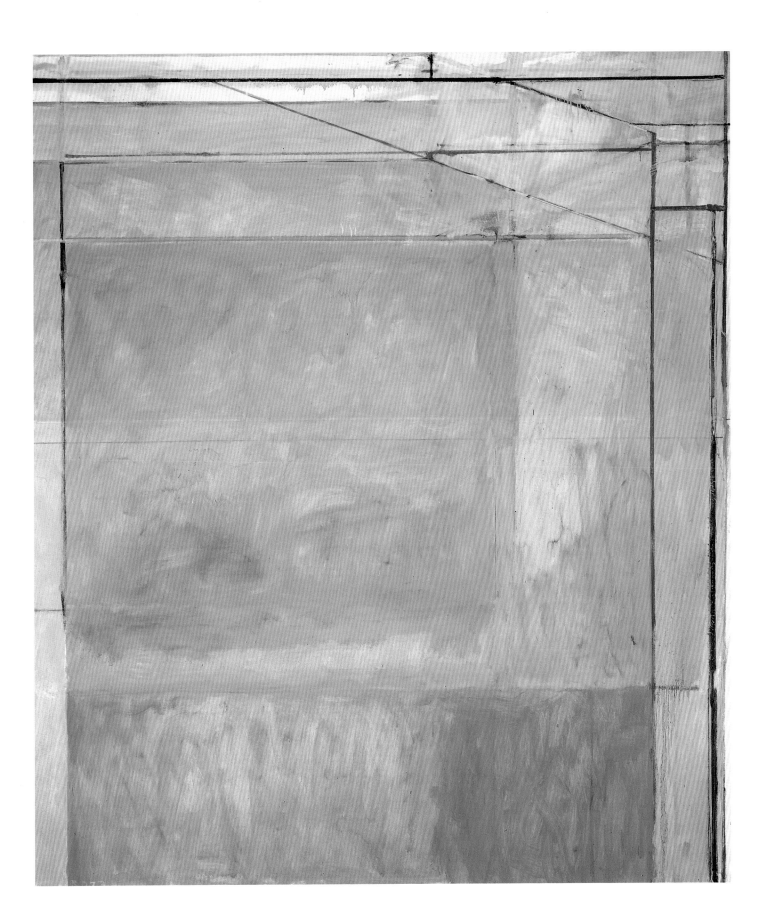

MOUSE CUP

ELIZABETH MURRAY

In the early 1980s, Elizabeth Murray broke with painting's conventional rectangular format and began making curved, multiunit canvases. Following Frank Stella, whose shaped canvases emphasize the literal objectness of painting, Murray explores the tensions between paint, surface, and support. By fragmenting single images across multiple canvases and reassembling them into highly expressive, dynamic figures, Murray pioneered a new visual language for painting.

While Stella mostly adheres to stark geometries, Murray uses a personal vocabulary of biomorphic forms that reference the everyday world—kitchen chairs, tables, coffee cups. *Mouse Cup* is an exemplary example of Murray's innovative style: in it, the abstracted rendering of a mug holds the shattered picture plane together. Two large, specially made canvases nestle into and nudge each other, with the white wall forming an actual break in the image of the mousey, swollen cup. Gray liquid spills from the dark hollow of the cup, swooping into six fingers of fluid that reach for the circular handle as if it could stop the flow. Green and blue planes suggest a table underneath, while the bulbous canvases mimic the blobs of the spill and the curves of the cup itself. The playful shapes tumble together in a visual rhythm that evokes organic motion. Rather than fit cleanly together, the two canvases curl and twist to emphasize the pressure between the painted shadows and the flatness of the wall.

Cartoons have had an enormous influence on Murray, and the crisp outlines and exaggerated forms of *Mouse Cup* are reminiscent of the bold, stylized drawings of comic strips. By blowing up common objects with a cartoonish humor, Murray flirts with a Pop art sensibility, yet she contrasts this with her painterly, energetic brushwork. She remains committed to the expressive touch of the artist's hand and to traditional materials; she often grinds her own pigments. In *Mouse Cup*, the thickly layered grays and shiny dark browns are animated by vigorous, visible surface handling.

Although she is sometimes categorized as a New Imagist (along with Jennifer Bartlett and Susan Rothenberg), Murray blurs the lines between abstraction and figuration. This synthesis allows her to delve into the unconscious, and lurking within her dense paintings are elements of violence or unease: objects collapse, fracture, and topple out of control. However, Murray always skillfully merges part and whole, high- and low-art forms, whimsy and pathos.

The curator Robert Storr has commented that Murray's psychological shapes and emotion-charged surfaces reveal a "decidedly female perspective."[1] She celebrates the typically "female" material world by imbuing familiar objects with an inner symbolism. Finding vitality in the still life, Murray draws her greatest inspiration from the domestic: "I paint about the things that surround me—things that I pick up and handle every day. That's what art is. Art is an epiphany in a coffee cup."[2] —JBW

ELIZABETH MURRAY
Mouse Cup, 1981–82
oil on canvas
2 canvases, 112 x 97¼ in. overall

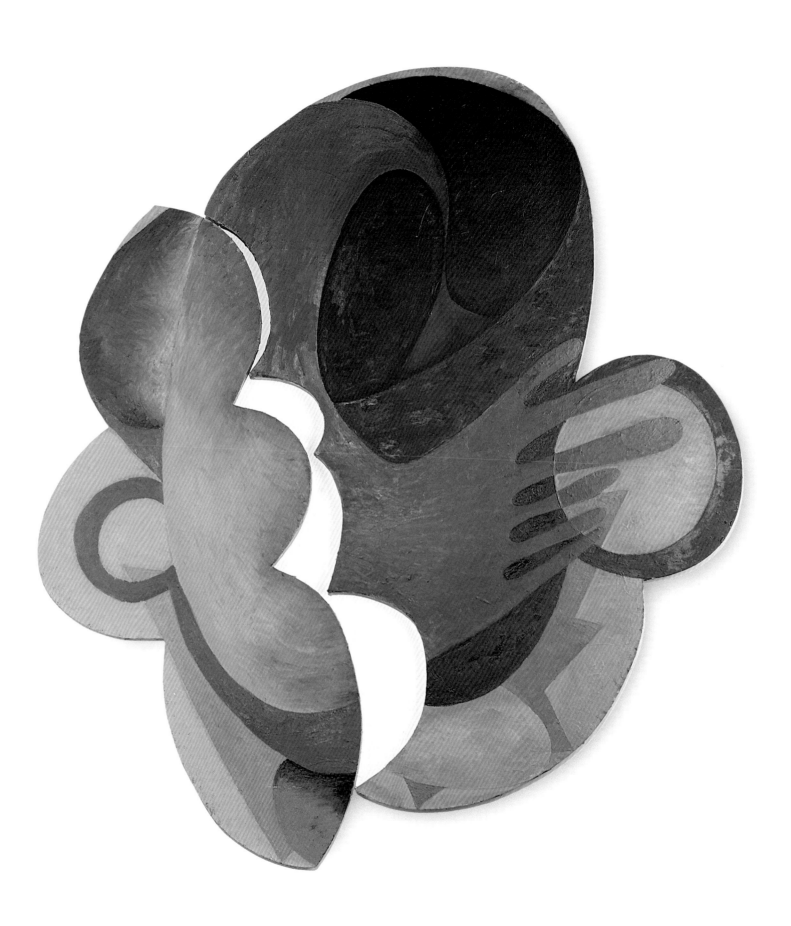

JENNIFER BARTLETT
At the Lake, Morning, 1979
enamel and serigraph on steel,
oil on canvas
45 steel plates and 2 canvases,
77 x 197 in. overall

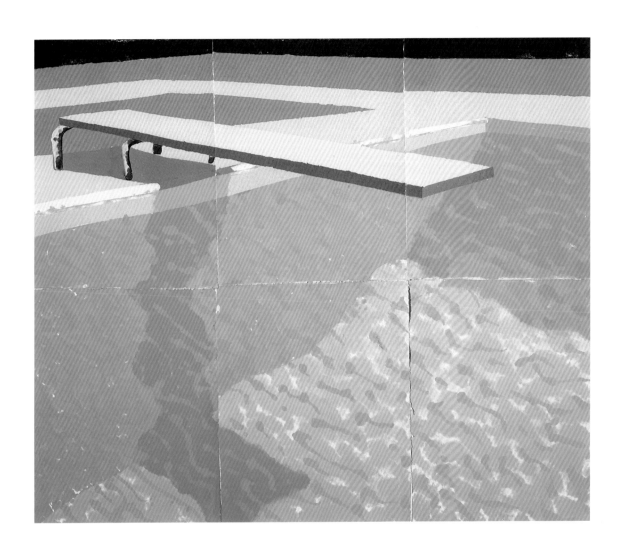

DAVID HOCKNEY
Sprungbrett mit Schatten
(*Paper Pool #14*)
(Diving Board with Shadow), 1978
pigment in paper pulp
71¾ x 84½ in.

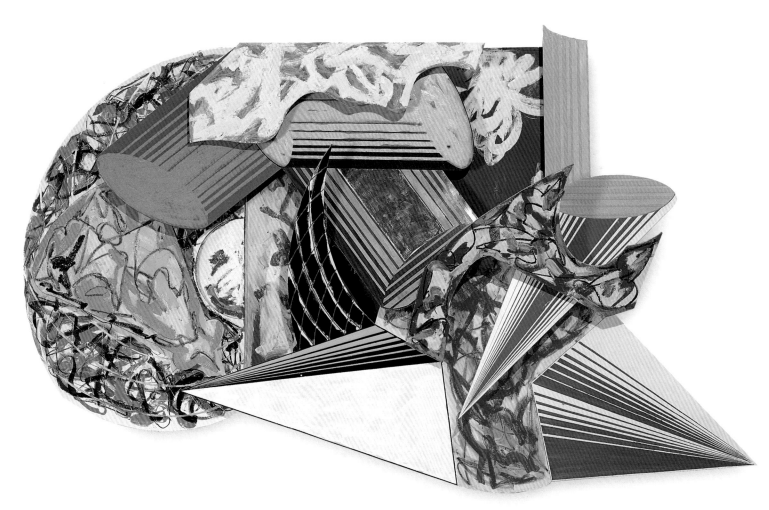

FRANK STELLA
Giufà, la luna, i ladri e le guardie
(Giufà, the Moon, the Thieves, and the
Guards), 1984
mixed media on canvas, etched
magnesium, aluminum, and fiberglass
123¾ x 198 x 27⅞ in.

opposite:
ROBERT HUDSON
Plumb Bob, 1982
enamel on steel, antlers, and mirror
102½ x 82½ x 72¼ in.

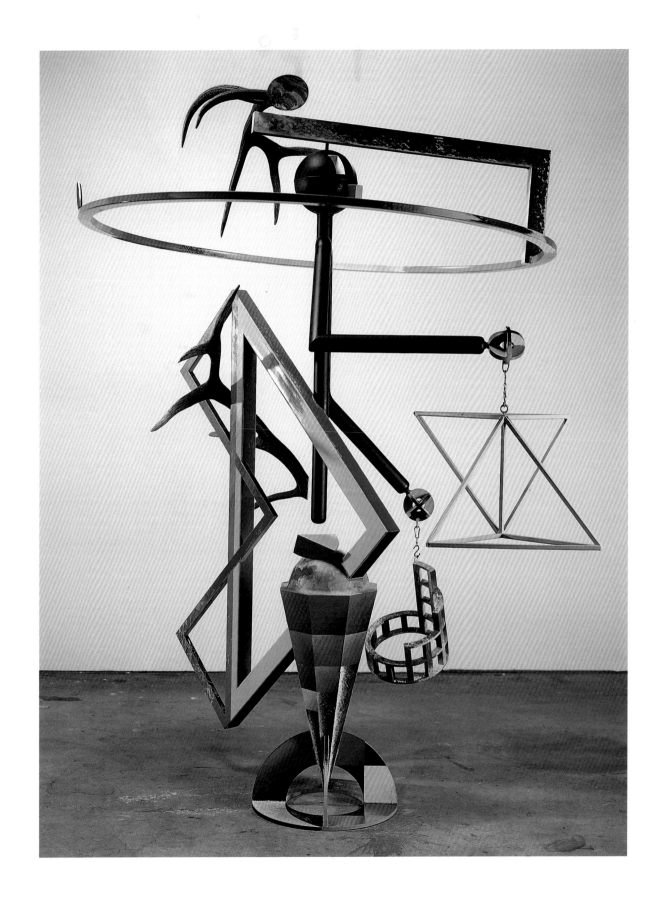

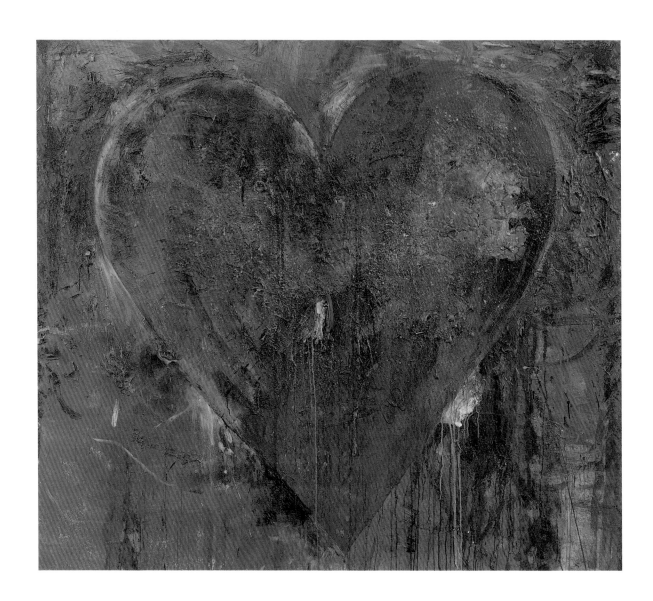

JIM DINE
Blue Clamp, 1981
acrylic, poured resin, and straw on
canvas with English C-clamp
84¼ x 96½ x 5 in.
San Francisco Museum of Modern Art,
Gift of Harry W. and Mary Margaret
Anderson

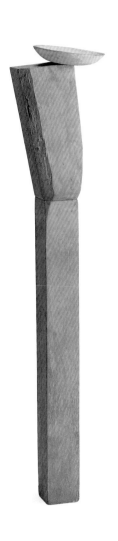

ROBERT THERRIEN
No Title, 1986
bronze, wood, and mixed media
44¾ x 8¼ x 6⅞ in.

DUMB COMPASS

TERRY WINTERS

Terry Winters painted *Dumb Compass* in 1985 during a transitional period in his career. In this work he confronted the difficulty of following up on his critical and commercial success of the early 1980s. *Dumb Compass* is a tough painting that records the artist's personal evaluation of his work and acts as a compass pointing to new directions for his art.

Winters began to experiment with his color palette in *Dumb Compass* by spreading a progression of colored discs across the top of the painting. The primary colors and uniform shape of the discs is a dramatic change from the painterly gesture and earth tones he had manipulated in his earlier works. Winters explained that the discs were "a way of staging a progression in size and color; a way of putting color on the painting in an arbitrary manner that can trigger unpredictable responses."[1] The two figures that dominate the left half of *Dumb Compass* are a more predictable motif, as they recall, in scale and presentation, Winters's paintings of botanical fragments from the early 1980s. But this pairing of uterine and priapic forms marks the beginning of the artist's interest in images of the human interior and specifically the reproductive system.

Unlike the clearly identifiable figures on the left, those in black outline on the right side of the canvas could have been taken from biology textbooks, medical imaging, or any number of art-historical and scientific sources Winters regularly used in his art. This proliferation of partial forms emphasizes a process of translation and mutation that was a central theme of Winters's work throughout the 1980s. The outlined forms were evolving in Winters's art before *Dumb Compass* and continued mutating after its completion. The images first appeared in 1984 as a series of drawings titled *Siren: Nine Drawings* and they surfaced again in nineteen works on paper titled *a-s*, in 1987. By exaggerating the process of mutation, Winters opened his paintings to broad interpretation.

Looking for new directions while remaining rooted in his previous work helped Winters find a way to transform his artistic project. In the second half of the 1980s the artist would embrace a bold new palette and in the 1990s he explored more abstract imagery. *Dumb Compass* helped initiate a process of transformation that would define Winters's painting and career. —RT

TERRY WINTERS
Dumb Compass, 1985
oil on linen
94½ x 132½ in.

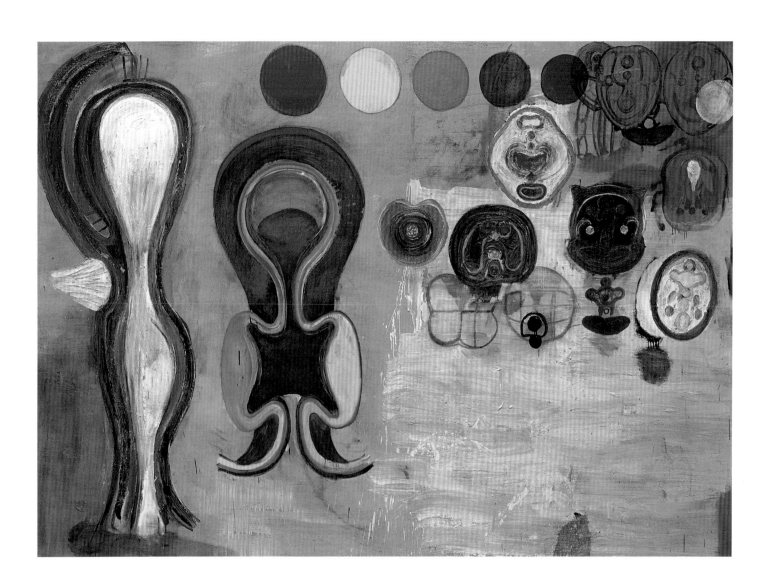

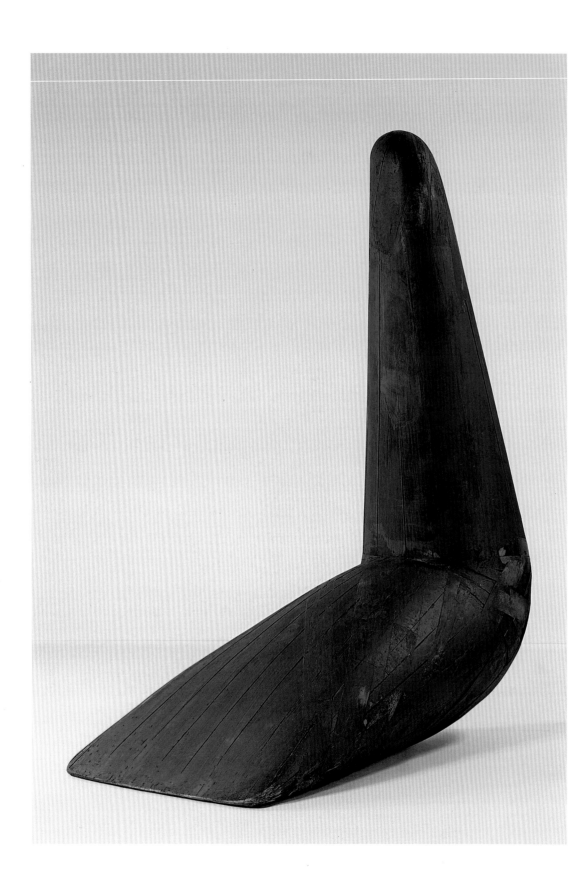

MARTIN PURYEAR
Lever (#4), 1989
painted red cedar
96 x 81 x 43 in.

opposite:
SUSAN ROTHENBERG
Wishbone, 1979
acrylic and flashe paint
on canvas
102 x 76 in.

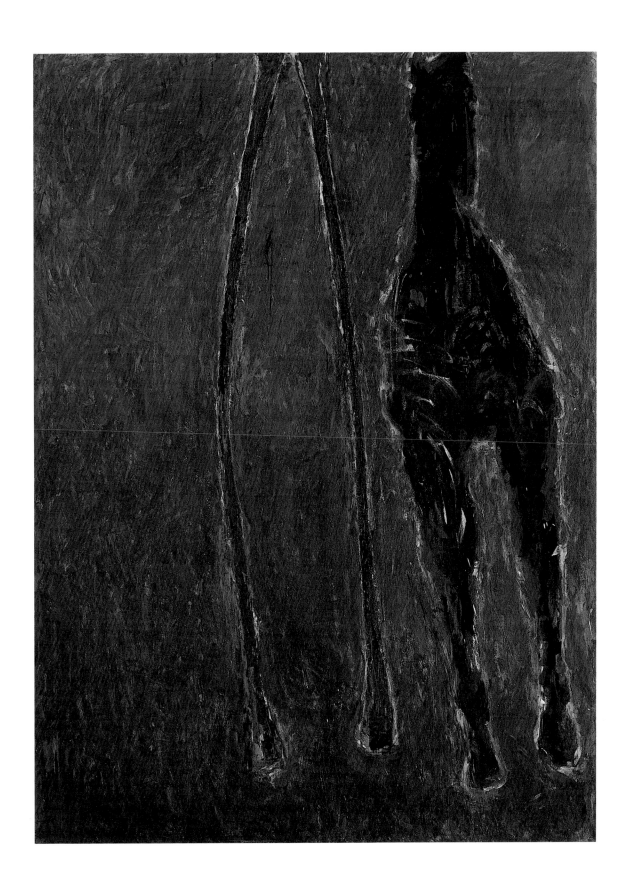

BRUCE CONNER
BALLET, 1981
ink on paper
22 x 29⅞ in.

VIJA CELMINS
Desert Surface #1, 1991
oil on wood panel
18⅛ x 21⅝ in.

TIM HAWKINSON
Untitled (*Door II*), 1990
wood, doorknob, handles, and hinges
78½ x 36½ x 6½ in.

MATTHEW RITCHIE
Three of a Kind, 1996
enamel on Sintra
108 x 111 x 23 in.

DEBORAH OROPALLO
Ascension, 1996
oil on canvas
96 x 52 in.

opposite:
MARK TANSEY
Yosemite Falls (*Homage to Watkins*),
1993
oil on canvas
108 x 79 in.

NOTES

EMIL NOLDE *Head of a Woman*

1. Quoted in Peter Selz, *Emil Nolde* (New York: The Museum of Modern Art, 1963), 38.
2. Ibid., 7.

ELIE NADELMAN *Man in the Open Air*

1. Elie Nadelman, "Notes for a Catalogue," *Camera Work*, no. 32 (October 1910).
2. Lincoln Kirstein, *Elie Nadelman* (New York: Eakins Press, 1973), 201.
3. Wanda M. Corn, *The Great American Thing: Modern Art and National Identity, 1915–1935* (Berkeley: University of California Press, 1999), 327.

JACKSON POLLOCK *Lucifer*

1. Pollock, 1946, quoted in Francis V. O'Connor, "The Life of Jackson Pollock, 1912–1956: A Documentary Chronology," in Francis Valentine O'Connor and Eugene Victor Thaw, eds., *Jackson Pollock: A Catalogue Raisonné of Paintings, Drawings, and Other Works* (New Haven: Yale University Press, 1978), vol. 4, 238.

WILLEM DE KOONING *Gansevoort Street*

1. Willem de Kooning, "What Abstract Art Means to Me," *Museum of Modern Art Bulletin* 18 (Spring 1951): 4.

FRANZ KLINE *Figure 8*

1. Harold Rosenberg, "The American Action Painters," *Art News* 51 (December 1952): 22.

ALBERTO GIACOMETTI *The Invisible Object (Hands Holding the Void)*

1. André Breton, "L'equation de l'objet," *Documents* 34, no. 1 (June 1934): 20.
2. See Reinhold Hohl, *Alberto Giacometti* (New York: The Solomon R. Guggenheim Museum, 1974), 22.

RICHARD DIEBENKORN *Girl on the Beach*

1. See Caroline A. Jones, *Bay Area Figurative Art, 1950–1965* (San Francisco: San Francisco Museum of Modern Art, 1990).
2. Quoted in Paul Mills, *Contemporary Bay Area Figure Painting* (Oakland: Oakland Museum, 1957), 12
3. Ibid.
4. Richard Diebenkorn, quoted in John Elderfield, "Figure and Field," *Richard Diebenkorn* (London: Whitechapel Art Gallery, 1991), 21.

JASPER JOHNS *Land's End*

1. Jasper Johns, quoted in Leo Steinberg, "Jasper Johns: The First Seven Years of His Art," in *Other Criteria: Confrontations with Twentieth-Century Art* (New York: Oxford University Press, 1972), 31.
2. Quoted in Michael Crichton, *Jasper Johns* (New York: Harry N. Abrams, 1977), 50.
3. Ibid.

WAYNE THIEBAUD *Candy Counter*

1. Stephen C. McGough, "An Interview with Wayne Thiebaud," in *Thiebaud Selects Thiebaud: A Forty-Year Survey from Private Collections* (Sacramento: Crocker Art Museum, 1996), 9.

PHILIP GUSTON *Window*

1. Quoted in William Corbett, *Philip Guston's Late Work: A Memoir* (Cambridge, Mass.: Zoland Books, 1994), 28.
2. Ibid., 35.
3. Quoted in Nicholas Serota, ed., *Philip Guston: Paintings, 1969–1980* (London: Whitechapel Art Gallery, 1982), 52.
4. Ibid.

JESS *The 5th Never of Old Lear*

1. Quoted in Michael Auping, *Jess: Paste-Ups (and Assemblies) 1951–1983* (Sarasota, Fla.: John and Mable Ringling Museum of Art, 1983), 15.

ELIZABETH MURRAY *Mouse Cup*

1. Robert Storr, "Shape Shifter," *Art in America* 77 (April 1989): 221.
2. Quoted in Deborah Solomon, "Celebrating Paint," *New York Times Magazine*, March 31, 1991, 40.

TERRY WINTERS *Dumb Compass*

1. Quoted in Jeremy Lewison, *Terry Winters: Eight Paintings* (London: The Tate Gallery, 1986), 15.